IMAGES
of America
VERO BEACH

This tourist map of Florida dates to 1923 or 1924 and shows how well developed the state was by that time. It is obvious that the main attraction on this particular map is Vero, because the town's name stands out by virtue of being printed in a much larger font and, in the original photograph, in red letters. Note that the Tamiami Trail is designated "under construction." (Indian River Historical Society Collection.)

ON THE COVER: In this mid-1950s photograph, members of the Vero Beach Art Club enjoy one of their regular outings, painting some of the local scenery. Originally called the Vero Beach Sketch Club, the group was founded in 1936 by five artists who met weekly. Having grown to include several hundred members, the club is involved in many activities and events that promote the creation and appreciation of art. (Indian River Historical Society Collection.)

IMAGES
of America
VERO BEACH

Teresa Lee Rushworth

ARCADIA
PUBLISHING

Copyright © 2014 by Teresa Lee Rushworth
ISBN 978-1-4671-1150-8

Published by Arcadia Publishing
Charleston, South Carolina

Printed in the United States of America

Library of Congress Control Number: 2013946833

For all general information, please contact Arcadia Publishing:
Telephone 843-853-2070
Fax 843-853-0044
E-mail sales@arcadiapublishing.com
For customer service and orders:
Toll-Free 1-888-313-2665

Visit us on the Internet at www.arcadiapublishing.com

This book is dedicated to Alma Lee Loy, the "First Lady of Vero Beach," and Wally Skiscim, our favorite photographer.

Contents

Acknowledgments		6
Introduction		7
1.	The Early Years	9
2.	Life, War, and Baseball	45
3.	Progress in a Small Town	79
4.	Towards the Close of a Century	107

Acknowledgments

This book would not have been possible without the work of Pamela Cooper, the supervisor of the Archive Center and Genealogy Department at the Indian River County Main Library. Her tireless efforts to preserve the history of Indian River County make the Archive Center the amazing resource that it is. I am also indebted to James Wilson, who scanned many of the photographs used in the book. His enthusiasm for the history of Vero Beach is inspiring. I am extremely grateful to all who contributed photographs to this project and those who spent hours sharing their knowledge and memories with me, especially Alma Lee Loy, Wally and Mary Anne Maher Skiscim, Dolores Schlitt D'Amore, Wanda Simmons Knight, Jan Robison, Sharon Shelton Gorry, and Bump Holman. I owe special thanks to Liz Gurley, my acquisitions editor at Arcadia Publishing, for her patient guidance and encouragement.

Key to collections in the Archive Center, Indian River County Main Library, from which images are included in this book:

IRCHS	Indian River Historical Society Collection
ABC	Antioch Baptist Church Collection
Brackett	Brackett Collection
Dodgers	Dodgers Collection
Godbold-Helseth	Godbold-Helseth Collection
Library	Library Collection
Sexton	Sexton Collection
Skiscim	Skiscim Collection
Smith	Bruce Smith Collection

Key to private collections from which images are included in this book:

DuBose	Courtesy of the DuBose family
Gifford	Courtesy of Charles and Margaret Cox Gifford
Hogan	Courtesy of Chet Hogan
Holman	Courtesy of Bump Holman
Kaser	Courtesy of the Kaser family
Knight	Courtesy of Wanda Simmons Knight
Leonard	Courtesy of Linda Leonard
Loy	Courtesy of Alma Lee Loy
MacIntyre	Courtesy of Bruce MacIntyre
Pfarr	Courtesy of the Pfarr family
Robison	Courtesy of Jan Robison
Gorry	Courtesy of Sharon Shelton Gorry
Schlitt	Courtesy of the Schlitt family
TBS	Courtesy of Temple Beth Shalom
Walker	Courtesy of Mary Sue Walker
MZMBC	Courtesy of Mount Zion Missionary Baptist Church
Author	Courtesy of the author

INTRODUCTION

In the late 19th century, a few brave and pioneering souls began settling in what is now Vero Beach and its environs. In those days, the Indian River was the main highway. Settlers arrived by boat, mail was delivered by boat, and even shopping was done on the river, when floating stores traveled through the area periodically. The Indian River also provided food for the pioneers settlers.

In 1887, Henry T. Gifford of Vermont was told by his doctor that a warmer climate might benefit his health. Leaving his wife, Sarah, and their smaller children behind, Gifford and his 20-year-old daughter Nettie May embarked on the arduous journey to Florida. They stopped in Fort Pierce, where a few families had already set up a permanent camp. After exploring the area to the north, Gifford found an area that he deemed suitable for a new settlement. The following autumn, with Nettie May having found a teaching post, Henry went back to Vermont and gathered Sarah, nine-year-old son Friend Charles, three-year-old Ruby Sarah, grown daughter Cora, and Cora's husband, Oramel, along with their three children; a new settlement was about to be born.

It was hard work: clearing land, finding food, and building shelters. The mosquitoes alone must have been daunting, even to these hearty people. But soon, other families arrived. Their names have become familiar to us, and many of their descendants still live in Vero Beach.

In 1891, Henry Gifford applied to the postmaster general for a post office in the settlement. Along with the five signatures he had gathered, the form required the fledgling town to have a name. It is Sarah Gifford who is credited with selecting the rather mysterious name Vero, which she is believed to have abbreviated from the Latin word for "truth," *veritas*. The application was approved, and Vero's first post office was the Gifford house. Mail was delivered once a week by boat.

The arrival of Henry Flagler's railroad in the 1890s began to put Vero on the map, but it was the arrival of Herman Zeuch, who purchased and drained the enormous parcel of land that became Indian River Farms, that drew new residents to this remote, subtropical region from all over the United States. With the potential of three growing seasons each year, the area offered tantalizing opportunities for both experienced and novice farmers. In the beginning, many different crops were grown, but eventually, citrus became king.

A happy coincidence of geography, climate, and soil properties places Vero Beach at the heart of a 200-mile-long but very narrow strip of land that offers optimal conditions for growing delicious citrus fruits.

Agriculture was not the only livelihood available to the early residents. Many successful businesses were established by the pioneer settlers, many of which continued for decades, and a few of which are still in existence today. The Town of Vero was formed officially in 1919 as part of St. Lucie County. The next six years were prosperous, and Vero outshone the surrounding towns. In 1925, a large group of Vero businessmen boarded a train to Tallahassee. They were on a mission: Vero was ready to become the seat of a brand new county. It was as a result of their labors that Indian River County was born, and the Town of Vero became the City of Vero Beach.

Like the rest of the nation, Vero Beach was affected by the Great Depression; but the town was resilient and continued to grow. When the United States became involved in World War II, like the rest of the nation, Vero Beach pitched in to do its part in the war effort. The US Navy selected the Vero Beach Municipal Airport to become the site of a naval air station. With the support of the local community, the base served as a training facility for Navy pilots. After the war, the airport returned to its civilian operations.

In addition to allowing Vero Beach residents to take pride in their involvement in the war effort, the presence of the naval air station brought an unexpected boon to the city. Thanks to the ingenuity and vision of local entrepreneur and Eastern Air Lines employee Bud Holman,

who realized that the open land adjacent to the airport could be converted easily into baseball diamonds and the barracks buildings could serve as lodgings for athletes, Vero Beach became the spring training home of the Brooklyn Dodgers. The relationship between the town and the team became a special one; even long after the Dodgers relocated to Los Angeles, they continued to travel to Vero Beach for their spring training until 2008.

In the 1950s, the Vero Beach Municipal Airport also provided a well-suited location for Piper Aircraft, which became a major employer in the town and eventually made Vero Beach its headquarters. Later, the FlightSafety Academy also found a home at the airport.

Vero Beach has built up its own distinctive cultural heritage, with art, theater, and music playing important roles in residents' lives, both individually and collectively.

The population of Vero Beach has grown steadily over the years, and the city has spread several miles to the west. Vero Beach is a popular destination for retirees seeking to trade their snow shovels for golf clubs. Many snowbirds split their time between homes in Vero Beach and homes in the northeastern United States or even Canada. And yet, somehow, Vero Beach has maintained an element of small-town charm. Its "downtown" consists of just a few intersections, and only two high-rise condominium buildings have slipped through the cracks of height restrictions. The beaches remain unspoiled, though erosion has been an issue. The Indian River Lagoon remains at the center of life here, but more for recreation than transportation these days. In recent times, environmental concerns have emerged with regard to the lagoon, and residents are realizing that the natural beauty of Vero Beach is not to be taken for granted.

This book will provide a glimpse into life in Vero Beach, from its pioneer days to modern times.

One

THE EARLY YEARS

This photograph was taken on the occasion of the 1923 wedding of John Schlitt and Florence Miller. Pictured, from left to right, are unidentified, Florence, maid of honor Mayme Jun, the groom's brother and best man Leo Schlitt, John, and unidentified. The marriage would produce eight children and generate a veritable dynasty within the community. A local colloquialism quips, "If you're out of Schlitts, you're out of Vero." (Schlitt.)

Friend Charles Gifford, flanked by two unidentified women, is shown around the 1920s on the porch of his historic family home. As a nine-year-old boy, he had arrived in Vero with his parents, Henry T. (or H.T.) and Sarah, and the rest of his family in 1888—one of Vero's very first pioneer families. In an early step towards establishing an infrastructure, H.T. and another gentleman cleared a 10-foot-wide path from Sebastian to Fort Pierce; this primitive road was the predecessor of US Highway 1. The Gifford house, the first frame home built within what are now Vero Beach's city limits, served as the town's first post office. When, in 1891, H.T. Gifford submitted the application to the postmaster general, five people had signed the petition. Mail was delivered once per week by rowboat. It is Sarah Gifford who is credited with selecting the town's name; it is believed she chose the name Vero based on the Latin word for "truth." (IRCHS.)

It is in large part due to the entrepreneurial spirit of Herman J. Zeuch, pictured here in a citrus grove with his wife, Adelaide, that Vero Beach is on the map. From his home in Davenport, Iowa, Zeuch travelled extensively around the United States before deciding to seek his fortunes in Florida. In 1912, he purchased 55,000 acres of what was to become Indian River County. At $3 per acre, the land was a bargain, except for one catch: much of it was submerged underwater. Zeuch recruited business partners, formed the Indian River Farms Company, and undertook a major drainage project. He then sold the farmland for $150 to $200 per acre. With a climate that allowed for three crops per year, adventurous men flocked to the area and helped to build Vero Beach into the city it has become. (IRCHS.)

Friend Charles Gifford (right) and an unidentified companion sit outside the railway station in the days when Vero was a freight-only stop and passengers used the Gifford depot (named for his family) just to the north. F.C. Gifford served as the first freight and ticket agent here, and often caught mailbags and freight as they were tossed to him from moving trains. The trains stopped when fragile freight was involved. (IRCHS.)

The 24-bed Sleepy-Eye Lodge was built by the Indian River Farms Company for the specific purpose of housing prospective land buyers who visited Vero to inspect the many acres of subtropical farmland being marketed by Herman Zeuch and his business partners, who invited men from all over the country with the motto "You can look without buying, but don't buy without looking." (IRCHS.)

John M. Knight and Burma Reed are shown on the occasion of their 1913 wedding. Burma had arrived in Vero via covered wagon as a toddler around 1897. The pair met at church shortly after John moved to Vero in 1911. For six years, the couple ran a grocery store and soda fountain just west of the railroad depot. Knight also became one of the area's early citrus men. (Knight.)

A Ford Model A automobile sits in front of the Twenty-second Avenue home of Louis Ludwig Schlitt, a German immigrant who moved from Missouri to Vero in 1918, along with his wife, Maryanna Boland, and three of their children. Like most of Vero's pioneer residents, they engaged in farming. They would serve as the roots of a family tree that thrives in Vero to this day. (Schlitt.)

The Pfarr family began its association with the Treasure Coast in 1914, when brothers Dane and Arthur Pfarr purchased some land and Arthur moved down from Ohio to seek his fortunes in the booming citrus business. His wife, Esther, found work as a schoolteacher. Meanwhile, Dane remained in Ohio and followed in the footsteps of their father, George, who had established the Mutual Electric Plant in Middleport, Ohio, in 1900, and had died in 1914. In 1918, Dane accepted a job as electric engineer with the Vero Utilities Company. The job would require him to run the town's new power plant singlehandedly, as he would be not only the chief engineer but also the only full-time employee. Despite his heavy responsibilities, Dane also joined Arthur in the citrus business. Shortly after their arrival in Vero, the Pfarr family was photographed on a dock; from left to right are daughters Margaret, Virginia, and Hortense; son George; and Dane and his wife, Alice. (Pfarr.)

When Dane and Alice Pfarr (pictured) moved to Vero in 1918, they settled into a wooden house on the corner of Twentieth Street and Tenth Avenue (shown above around the 1940s). Home to three generations of Pfarrs, the house was sold in the 1980s. Despite an addition for office space, the historic house is still recognizable. It is now the home of *Vero Beach Magazine*. (Pfarr.)

Prior to 1920, the only way for Vero residents to cross the Indian River was by boat. In 1920, a wooden swing bridge was constructed. A section in the center of the bridge would swing horizontally, allowing boats to pass. This operation required the full-time presence of a bridge tender, whose small house stood on the bridge itself. The bridge was destroyed by a hurricane in 1926 and rebuilt in 1927. (IRCHS.)

Prior to 1919, Vero's Catholic residents had to catch a 6:00 a.m. train every Sunday morning in order to attend 8:00 a.m. Mass in Fort Pierce. In June 1919, a small congregation raised enough money to build the wooden church seen above. The new parish adopted the name of St. Helen. At that time, a single priest covered the entire region from Rockledge to Okeechobee. (IRCHS.)

Established in 1915 as the Farmers Bank and Trust Company, Vero's first bank closed and reorganized in 1927, reopening as the Farmers Bank of Vero Beach, with $75,000 in capital. It was touted by the *Miami Daily News* as occupying "one of the most modern and completely appointed banking houses on the east coast." The bank is shown here after its reopening. (IRCHS.)

Born in Scotland in 1891, Alexander "Alex" MacWilliam emigrated with his family at age 18, settling in Cleveland, Ohio. MacWilliam served as an infantry lieutenant in World War I and was highly decorated, receiving the Distinguished Service Cross, the Silver Star, the Purple Heart, and the French Croix de Guerre for heroism. Wounded in both legs by machine gun fire, he returned to Cleveland before moving at age 28 to Vero, where he became an extremely active member of the community. He was a member of the 65-man delegation that took a train to Tallahassee in 1925 to push for the separation of Indian River County from St. Lucie County. Less than two years later, he became the fourth mayor of Vero Beach. His public service continued as he logged a total of 20 years in the mayor's office and 10 in the Florida House of Representatives. He established the local Mosquito Control Board, introduced building height restrictions, and spearheaded the creation of the Veterans Memorial Island Sanctuary, in honor of local residents who have died while serving the United States. (IRCHS.)

In 1914, a 37-year-old Peter Leffler relocated his family, including his wife, Elizabeth, whom he had married in 1904, from Illinois to Vero. They established a homestead at Eighth Street and Twenty-fourth Avenue, where, like many early residents, Leffler grew citrus trees. Shown on the front porch of their small home, from left to right, are Peter; his two daughters Florence and Mamie; and Peter's bachelor brother William, who was one year older than Peter. Life could not have been easy for the Lefflers; an accident injured Peter's left arm, and his wife, Elizabeth, died in 1924 at the age of 36, after having suffered several bouts of lung trouble. Only two years prior to Elizabeth's passing, their daughter Edna Agnes had died at the age of two years, after having suffering for more than a week with symptoms resembling those of croup. (IRCHS.)

This postcard shows the spacious Vero Beach Elementary School, which was touted as a thoroughly modern educational facility when it was built in 1919. In included drinking fountains and the most up-to-date restroom facilities available at the time. More than 300 students were enrolled for the first school year in the new building. (Smith.)

In 1919, the town council of the newly incorporated Vero established a much-needed fire department, partially in response to the 1918 fire that destroyed the block of businesses on the south side of Osceola Boulevard (Twentieth Street) between Fourteenth and Fifteenth Avenues. The town's first fire truck was a Ford Model T. In 1923, the 18-member all-volunteer force obtained a hook and ladder fire truck. (IRCHS.)

This 1922 photograph shows the first jewelry store in Vero. Proprietor J.C. DuBose (center) was a Baptist minister who arrived in Vero in 1912 and founded both the First Baptist Church and DuBose Jewelers. Son Oscar (right) was the second of five generations to work in the family jewelry business. J.C.'s wife, Alice, is seated at the desk at left. (IRCHS.)

In this photograph, possibly taken in 1932, a group of women and children waits outside the train station. Note the word *white* above the waiting room entrance on the left, and the barely visible word *colored* over the door on the right—reminders of one of the more ignominious aspects of American history. (IRCHS.)

Eight of Vero Beach's earliest residents enjoy a day at the beach in 1926. Pictured, from left to right, are Anne Eckhoff, Cornelius Schlitt, Alma Schlitt, Mamie Leffler, Dominic Romani, Ralph ?, Leo Schlitt, and Eva Wodtke. Cornelius was known to enjoy daily exercise throughout his life, and it must have been beneficial—he lived to the age of 101. (IRCHS.)

Several 1927 newspaper articles chronicle the origins of the Vero Beach High School football team. About 20 prospective players "had their first initiatory lesson in the mysteries of the popular game." Equipment consisted of leather helmets, red sweaters, and rugby balls. The students, with an average weight of 145 pounds, lost their first game in a shutout to Okeechobee High School, but the fledgling team made a good showing. (Godbold-Helseth.)

Thomas Jun moved from Illinois to Vero in 1919 and opened a grocery store at 1413 Osceola Boulevard. Jun ran the store until his retirement in 1944, when he sold it to E.W. Jacocks. The above photograph shows a 1950 window display highlighting the dramatic changes seen by the American consumer over the previous 25 years. Jun, shown at left with his wife, Flora, several years after his retirement, was an active member of the community, serving on the city's planning and zoning board and also joining 64 other local men on a historic 350-mile journey to Tallahassee in 1925 to lobby on behalf of the bill that would create Indian River County. (Above, IRCHS; left, Schlitt.)

Four Seminole women in traditional dress were photographed on a visit to downtown Vero Beach in 1925. The woman on the right holds a bucket in which she likely carries huckleberries to be traded. It was the habit of the Seminole women to come into town once a week to obtain provisions at Jun's Grocery Store. (IRCHS.)

This photograph shows Vero Beach High School's class of 1925. The nine graduates are, from left to right, (first row) Thelma Smith and Gladys Honeywell; (second row) Mary Carlsward, Marcia Nisle, and Jean Powers; (third row) Othmar Zigrang, Frank Lucas, James Scott, and Stuart Bartlett. (IRCHS.)

23

The Royal Park Inn was a three-story luxury hotel built in 1925 on the site of the present-day Royal Park Condominiums on Ponce De Leon Circle. Of particular note are the windows shown at the center of the above photograph. The exquisitely appointed dining room, with its arched windows, is shown below. The inn offered a Sunday night buffet for the price of $1. Diners were serenaded during their meals by the Royal Park Inn String Trio. Despite its architectural beauty, the Royal Park Inn was demolished in 1965 in order to make way for the next building project. (Both, IRCHS.)

Vero's first beautician, Elizabeth "Betty" Zigrang (right), sits in her beauty shop with sister-in-law Vera Ingalls, who would go on to own the Smart Shop clothing store from 1947 to 1973. Note the hair dryer at center and the frightening permanent wave machine above Betty's head. Betty was the wife of Othmar Zigrang, who ran Zigrang Grove Services, the business founded by his father, Dominick Frank Zigrang. (IRCHS.)

The basketball team shown at right represented Vero for the 1924–1925 season, as indicated by the writing on the basketball. It is, most likely, a semiprofessional team that played teams from other towns. Hugh Keffer (far right) served as coach, though his primary job was as a druggist at the Osceola Pharmacy. The building in the background is the Royal Park Inn. (IRCHS.)

The Vero Beach Municipal Airport, established in the late 1920s, was the brainchild of Bud Holman. It began as little more than three grass runways and a few hangars. For a town with a small population, though, an airport was a major acquisition. At left, local residents gather in front of the tiny building that served as the terminal. (IRCHS.)

In the early 1930s, Bud Holman, James Tew, and J.J. Schumann convinced Eastern Air Transport (later Eastern Air Lines) to use Vero Beach as a fuel stop on its routes run for the Post Office Department. Soon after, Vero Beach became the second city on Florida's east coast (after Jacksonville) to send and receive airmail—and the smallest US city to boast such service.

The American Red Cross was established in Vero Beach when the local chapter received its charter in 1926. In order to obtain the charter, three responsibilities must be shouldered: to lend assistance in times of disaster, to offer aid to servicemen, and to assist veterans when circumstances warrant it. The Red Cross building is located at 2506 Seventeenth Avenue. (IRCHS.)

The First Baptist Church was one of Vero's earliest churches, founded in 1915 by 15 charter members and their pastor, J.C. DuBose, who also established Vero's first jewelry business. They were confident that their congregation would grow rapidly, and so, within a year, they had built a sanctuary that could seat 300 worshippers. A 1936 addition brought the capacity to 500. The church is shown here in the early 1950s. (IRCHS.)

This postcard sketch depicts the downtown intersection of Fourteenth Avenue and Twenty-first Street, where Larry Paul Simmons owned a dry goods store from the mid-1920s well into the 1950s. The store sold yard goods, shoes, and clothing, including men's tailor-made suits. The family sold the business shortly after Simmons suffered a stroke in 1956. (Knight.)

Brothers Arthur and Dane Pfarr, like many of Vero's pioneer residents, found success in the citrus business. For a time, they ran the Island Fruit Market and White Chimneys Restaurant, located on the short segment of US Highway 1 that runs east to west. They sold the business to the American Fruit Growers in 1946. (Pfarr.)

In 1919, brothers John and Leo Schlitt, having served in World War I, were curious about why their parents, Louis and Maryanna, had settled in the mosquito-infested swamp of Vero. Like their parents, they fell in love with the little town and settled down on small family farms. John's little house is shown here, before numerous additions were built to accommodate his growing family. (Schlitt.)

Though life in early Vero revolved around citrus, members of the Schlitt family entered into various fields. Above, John Schlitt Sr. stands by a fruit tree with his first three children—from left to right, Edgar, who became successful in real estate; Frank, who continued the painting business started by his father; and Florine, who worked as a teller at the Indian River Citrus Bank before becoming a homemaker. (Schlitt.)

This photograph, which dates to the 1930s, shows the southwest corner of the intersection of Fourteenth Avenue and Twentieth Street, with a view extending west on Twentieth Street. In addition to Osceola Pharmacy, both Friedlander's Department Store and Jun's Grocery are visible. At the Illinois Hotel, visitors could enjoy a single room for $1.50 per night or a double for $3. (IRCHS.)

In 1915, a group of 27 women formed the Vero Beach Woman's Club. The first president was Irene Young, wife of first mayor Anthony Young. Membership dues were 50¢ per year, and the group's first priority was the foundation of a public library. With land donated by the Indian River Farms Company and 500 donated books, the library was ready in 1916, sharing this building with the Woman's Club. (IRCHS.)

1932 - 1948

Prior to May 1932, the nearest hospital available to Vero Beach residents was more than 70 miles away. Garnett Lunsford Radin, a Nebraska-born nurse, moved to Vero Beach in 1931 at the age of 29 and took it upon herself to found a hospital for the growing community. With $22,000 of her own money, Radin purchased this building (a hotel built in 1925 but never opened, for financial reasons) on Old Dixie Highway and converted it into a 21-bed hospital. The water was supplied by an artesian well, the only heating came from a wood-burning stove, and the kitchen facilities were in a separate building. Hospital rates were $5.00 per day for a private room and $4.50 for a double. (Both, IRCHS.)

Dr. A.C. Thompson is shown in the late 1930s with the acolytes and choir members of Trinity Episcopal Church, which was founded in 1926 as a mission of St. Andrew's Episcopal Church in Fort Pierce. A new church building was completed in 1931, but a full-time resident rector was not obtained until 1944. Trinity became a full-fledged parish in 1951. (IRCHS.)

Like several other religious groups, the Christian Science faith has been represented in Vero since its earliest days. In 1919 a community of Christian Scientists began meeting in Vero, and by 1923, members were worshiping in the characteristically Florida-style building they had erected at the corner of Sixteenth Avenue and Twenty-third Street (seen in this undated photograph). In 1924, it officially became the First Church of Christ, Scientist. (IRCHS.)

Business partners Waldo Sexton and Arthur McKee both purchased land in Vero Beach for development and citrus planting, but both men agreed that the 80 acres of tropical hammock that they bought together, a bit of which is pictured here, should be preserved. In fact, the two visionaries did more than just preserve the site; they embellished it in ways that would make it a major attraction. (Sexton.)

In addition to 110 varieties of palms, more than 40 types of rubber trees, 200 species of ferns, an enormous assortment of orchids, and the nation's largest array of tropical water lilies able to live outside year-round, McKee Jungle Gardens also housed a collection of exotic birds, such as the parrots pictured here. (Sexton.)

This photograph shows the parking lot of McKee Jungle Gardens shortly after its opening in 1932. At the center, in the midst of the vehicles, stands one of the attraction's many curiosities: a giant cypress stump that is believed to be over 3,000 years old. The stump is a relic of one of the largest trees ever seen east of the Mississippi River and is estimated to weigh 12 tons. (Sexton.)

Thomas Howell poses with a whale skeleton that was on display at the entrance to McKee Jungle Gardens. Despite the allure of impressive attractions, public interest eventually waned, and the gardens closed in 1976. Though the land was sold for the construction of condominiums, a "Save McKee Jungle Gardens" campaign allowed 18 of the original 80 acres to be purchased by a nonprofit group; it exists today as McKee Botanical Garden. (Sexton.)

Demonstrating his taste for the exotic, Waldo Sexton, having donned a pith helmet, interacts with a group of spider monkeys that had been imported to McKee Jungle Gardens. The imagination shown by Sexton and McKee made the gardens a major tourist attraction. Note the monkey that seems to be giving Waldo an affectionate hug. (Sexton.)

In this photograph, taken in the late 1920s or early 1930s, pioneer resident Waldo Sexton (left), along with Adelaide and Herman Zeuch (right) flank David McCormick, the first golf pro at the Vero Beach Country Club. Established in 1924, the country club is one of the oldest in the area. (IRCHS.)

The Theatre Plaza, shown here in the 1930s, has always been at the heart of downtown Vero Beach. In 1989, Robert Brackett, who had worked as an usher at the Florida Theatre in 1947, purchased and renovated the building, which houses businesses on the first floor and apartments upstairs. The grand opening took place in 1991, and in 1992 the site was added to the National Register of Historic Places. (IRCHS.)

The Parkway Building, located at the southeast corner of Eleventh Avenue and Twenty-first Street, was built in 1925, with offices occupying the first floor and 14 apartments on the second. It is shown here in the late 1930s, around the time it became the Parkway Hotel. The building, a classic example of the Mediterranean Revival style, was added to the National Register of Historic Places in 1998. (IRCHS.)

In 1926, Vero Beach architect William Garns was hired by Clayton Gleckler to design a small apartment building. The result was the Mediterranean Revival–style building that came to be known as the Royal Park Apartments. Pictured around the mid-1930s, the building has changed hands several times, yet remains a classic example of Vero Beach's historical architecture. (IRCHS.)

This photograph gives a peek inside a packinghouse in 1937. Conveyor belts move the citrus and empty crates, while workers wrap the fruit and place it into crates marked "Indian River Oranges & Grapefruit." In the foreground, one woman looks up at the camera, while behind her, two coworkers seem to share a laugh. In the background, nine more workers pause from their labor to capture the moment. (IRCHS.)

When the first settlers arrived in the area in the 1880s, the Indian River was the only thoroughfare by which pioneer residents obtained mail, supplies, and access to other communities. Within a decade, Henry Flagler's Florida East Coast Railway, which was progressing southward, reached Gifford, the settlement just north of Vero, and then Vero itself. The date of construction of the depot is disputed; it is shown here in the early 1920s. (IRCHS.)

The crowd of people in this photograph appears to be awaiting the train, as people stand very near the tracks with their luggage. Notable businesses in the background are Jimmy's Dry Cleaners (far right) and the Blue Lantern Inn, a hotel owned by Alexander and Margaret Ryburn (far left). Perhaps most perplexing about this photograph is the unusual wardrobe choice of the checker-clad gentleman in the center. (IRCHS.)

In its early days, Vero was home to several Knight families who were not directly related to one another. One owned a large bar and liquor store at the corner of Twentieth Street and Old Dixie Highway. This undated photograph must have been taken after 1933, the year Prohibition ended. Note the gas pumps at neighboring Sinclair Gasoline at the far right. (IRCHS.)

The Rainbow Tea Room was a popular café in the 1930s. This 1937 photograph shows, from left to right, an unidentified guest, owners Bayard and Alice Redstone, and employees Gussie Noble and her mother, Zylphine Noble. B.T. Redstone had served as Vero Beach's third mayor, from 1923 to 1927, and then was a member of the state House of Representatives for Indian River County from 1928 to 1933. (Smith.)

This 1964 photograph shows the ocean side of the aptly-named Driftwood Inn, which was built by Waldo Sexton during the 1930s and has been a unique attraction ever since. The hotel bears Sexton's signature in many ways: Its very construction pays tribute to his penchant for unusual wood varieties, the interior demonstrates his eclectic collecting habits, and the resort includes a restaurant called Waldo's. (Smith.)

After years of conducting its court-related business in rented space on the second floor of the Seminole Building on Fourteenth Avenue, Indian River County got a proper courthouse in 1936. The $75,000 building, also located on Fourteenth Avenue, measured 24,000 square feet, including a single 2,500-square-foot courtroom on the second floor. Note the streetlight at the curb. (IRCHS.)

The nine ladies pictured here are founding members of the local chapter of the Phi Beta Psi sorority, a national civic organization first organized in 1904. The group engages in various types of charitable work and is open to women who are at least 18 years of age, have graduated high school, and display high moral standards. The Vero Beach chapter, known as Beta Alpha, was established in 1928 by a group of ladies whose families were pillars of the community. Pictured, from left to right, are (seated on the ground) Viola Loy and Kate Schilling; (standing) Ruth Helseth, Florence Leffler, Anne Eckhoff, and Thelma Berggren; seated on the ladder, from top to bottom, are Vera Ingalls, Ruth Schumann, and Elizabeth Zigrang. Both Loy and Schumann would go on to serve as national officers in Phi Beta Psi. (IRCHS.)

The Carlsward family was one of Vero's several Scandinavian pioneer families. In the early 1900s, the Carlswards emigrated from Sweden and settled initially in Illinois and Iowa. In 1914, Arvid Carlsward and his wife, Hilda, relocated to a 10-acre farm in Vero. Two years later, Arvid's brother Herman, along with Herman's wife, Alma, and daughter, Mary, followed. Together, the two families would rear nine children in Vero. (IRCHS.)

The Community Church of Vero Beach was formed in 1924 with 83 charter members, who worked hard for the next five years to complete the beautiful house of worship shown here about 10 years after its construction. The congregation experienced substantial growth over the years, necessitating the construction of a larger church building in 1955. (Smith.)

On August 31, 1917, the following headline ran in the *Fort Pierce News*: "Vigorous Vero to Get Electric Lights." When the Vero Utilities Company was formed that year, a 25-horsepower oil motor operated the small generator that would provide electricity to its 40 customers. The streetlights came on in Vero for the first time on the night of Monday, December 3, 1917. In the ensuing eight years, the number of customers served by Vero Utilities increased a hundredfold, necessitating the construction of a new power plant. In 1925, the engineering firm of Carter and Damerow built the diesel power plant, which is shown in this 1940s photograph. This plant generated all of the electricity for the city of Vero Beach until 1961, when a more modern plant was built. The diesel power plant continued to serve as a backup until 1992. In 1994, the inner workings were dismantled, but the outer building was later restored. It was added to the National Register of Historic Places in 1999. (IRCHS.)

When the power plant was built in 1925, it began with a 750-horsepower diesel engine, which translates into 560 kilowatts. Over the years, as the city's power demands increased, the power plant's output capacity had to keep pace. By 1952, it was up to 2,875 kilowatts. By comparison, the new 1961 power plant was equipped with a 12,500-kilowatt steam electric generator. Nevertheless, the inner workings of the diesel plant were impressive. The original 750-horsepower engine weighed 150 tons. The flywheel, seen at left above, weighed 16 tons, and the crankshaft weighed nine tons. The above and below photographs of the old plant's equipment were taken in 1994, at the time the plant was being dismantled. (Both, IRCHS.)

Two
LIFE, WAR, AND BASEBALL

The fancy produce display pictured here is one of the exhibits featured at the annual Indian River Fruit Festival and County Fair that was held at the Community Hall built for that purpose in the late 1930s. The building, which was adjacent to Michael Field, was also used for other events, such as dances, over the years. The site later became the home of the Elks Lodge. (IRCHS.)

The Indian River Citrus League was founded in the early 1930s and then reorganized in 1948. Its headquarters, shown above, was located at the corner of Twentieth Street and Thirteenth Avenue. Its purpose was to promote the Indian River Citrus brand and prevent misuse of the Indian River Citrus brand name. The need for such an organization arose when citrus growers from areas outside the Indian River Citrus District were caught marketing their citrus under the Indian River name. In fact, a very specific combination of geological and climatic conditions form a very narrow, yet 200-mile-long, strip of land that is capable of producing the unique citrus fruit worthy of the Indian River name. The Vero Beach billboard shown below is an example of the promotional work done by the Indian River Citrus League. (Both, IRCHS.)

This photograph, taken around 1940, shows two of Vero Beach's most prominent engineers: Egerton Everett "E.E." Carter (left) and Harry Damerow. E.E. followed in the engineering footsteps of his father, Robert Daniel "R.D." Carter, who was responsible for carrying out Herman Zeuch's herculean land drainage project in the 1910s. Though the Great Depression cut short E.E.'s formal education, he became a licensed surveyor and took the position of road and bridge superintendent for Indian River County. Damerow, who was born in Iowa in 1891, was a civil and electrical engineer who served with the 23rd US Engineers in World War I. He also served Vero Beach as city engineer and superintendent of the Department of Public Works. In 1919, together with R.D. Carter, he formed the firm of Carter and Damerow, which, among other accomplishments, designed Vero's historic diesel power plant. (IRCHS.)

Members of the Kennedy family had lived in Vero Beach for decades when the fruit stand shown here opened in 1953. John A. Kennedy, who moved to Vero from Gainesville in 1908, began with 18 acres of citrus. In 1992, the Kennedys sold their two retail stores to fellow citrus giant Hale Groves, but they continued to own thousands of acres of groves and a packinghouse. (Smith.)

Pocahontas Park has been the site of many attractions and activities over the years, including a small zoo, tennis, croquet, a wading pool, and a playground. The shuffleboard courts were opened officially on Labor Day in 1929. In preparation for the event, the *Vero Beach Press Journal* printed the rules of the game in its August 30 issue. Here, locals and winter visitors enjoy a shuffleboard match in the 1940s. (IRCHS.)

Built in 1941 by Waldo Sexton, the Ocean Grill Restaurant was furnished with a solid mahogany dining table—the largest of its kind. Like many of Sexton's projects, the dining room shown here evinces both rustic coarseness and a certain offbeat elegance. The giant mahogany table remains in place to this day. (Sexton.)

DuBose Jewelers was the first business in Vero Beach to carry Hallmark cards, beginning around the mid-1940s. This photograph, taken around the early 1960s, shows the Hallmark card display in the DuBose shop in the Arcade Building on Fourteenth Avenue. The Arcade Building was owned by the DuBose family from 1944 to 1990. (DuBose.)

As the son of pioneer settler H.T. Gifford, Friend Charles Gifford (named for his grandfather) arrived in Vero as a nine-year-old in 1888 and helped create the town of Vero. As a teen, he assisted Henry Flagler's team in laying Vero's first railroad tracks. By his later years, he was known as "Uncle Charlie" throughout the town. In this photograph, he is selling guava jelly outside the Citrus Bank. (IRCHS.)

The three buildings shown in this photograph are facing eastward on Thirteenth Avenue. To the right of Mather Furniture and Appliances is the quaint little building that housed the Forrest Graves Real Estate company. The A&P Supermarket was a new and improved 3,700-square-foot store opened in 1936, replacing the older 1,500-square-foot store. The new store boasted state-of-the-art refrigerators, display cases, and an electric meat slicer. (IRCHS.)

This 1950s eastward-facing aerial view shows the beautiful Vero Del Mar (lower left), built in 1926 as Vero Beach's "million dollar hotel," on the former site of the Sleepy Eye Lodge. The 75-room luxury hotel was the brainchild of developer Andrew McAnsh. It was demolished in 1962 to make way for a downtown parking lot. (IRCHS.)

In his 14th year as mayor of Vero Beach, combat-wounded World War I hero Alex MacWilliam (front left, in dark uniform) leads Vero Beach's 1941 Armistice Day parade, joined by other veterans, who are followed by the Vero Beach High School marching band. MacWilliam served two nonconsecutive stints as mayor, from 1925 to 1945 and again from 1949 to 1951. (IRCHS.)

This aerial photograph shows the naval air station that was established when the US Navy selected the Vero Beach Municipal Airport as the site of a new base that would serve as a flight training facility during the last three years of World War II. After the war, the property was returned to the City of Vero Beach. (IRCHS.)

This photograph, taken during World War II, shows three SB2 dive bombers on practice maneuvers over the citrus groves of Vero Beach. Photographer's Mate First Class Walter "Wally" Skiscim, who took the picture, flew in the SB2 one time and, even nearly 60 years later, stated emphatically that he would never do so again. The aircraft, nicknamed "Helldiver," was notorious for its difficult handling. (IRCHS.)

Navy photographer Wally Skiscim photographed this row of T-6 Texan advanced training aircraft, which were built by North American Aviation. This single-engine airplane, known in the Navy by the designation SNJ-6, had a double cockpit; the student pilot sat in the front section and the instructor in the aft cockpit. (IRCHS.)

Wodtke's Department Store was a mainstay of Vero Beach's retail life for 53 years. Indiana native William Wodtke Sr. relocated to Vero in 1920 and, in 1942, partnered with Milton Walters to open a department store on Fourteenth Avenue. This photograph shows the store as it was adorned for its participation in the Seventh War Loan Drive, which began shortly after VE Day in May 1945. (IRCHS.)

53

When the United Service Organizations (USO) hosted a show at the naval air station, musicians provided entertainment and local young women joined the sailors for an evening of wholesome distraction from the war. In this photograph from the mid-1940s, several unidentified couples seem to be enjoying themselves alongside Vero Beach native Mary Anne Maher and Photographer's Mate First Class Wally Skiscim (second couple from right). (IRCHS.)

On August 20, 1945, just days after the end of World War II, the entire staff of Naval Air Station Vero Beach gathered for a photograph. The shot was taken by Photographer's Mate First Class Wally Skiscim, who set the camera's timer and then jumped into place. He is in the fourth row, second to the right of the center pole, sailor's cap askew. (IRCHS.)

By the end of World War II, Vero Beach's civilian hospital was being run by a nonprofit corporation formed for that express purpose, and the city's health-care needs were outgrowing the 13-year-old facility on Old Dixie Highway. Three years after the war, the hospital moved into the dispensary at the former naval air station, where it remained until 1952. (IRCHS.)

On November 11, 1946, a large celebration in honor of Armistice Day (Veterans Day) was held in Pocahontas Park. Here, 26 local American Legion men, most clad in aprons, take a break from preparing and serving food to pose for a group photograph. Always patriotic, the citizens of Vero Beach turned out in large numbers for Armistice Day festivities. (IRCHS.)

Most of the population of Vero Beach appears to have turned out for the late-1940s Fourth of July parade pictured. The parade is heading south on Fourteenth Avenue. Note the military personnel marching behind the jeep, and the spectators standing atop the marquee of the Florida Theatre. The car towing the Community Church children's float is turning onto Osceola Boulevard (Twentieth Street). (IRCHS.)

When Orla and Leah Shelton arrived in Vero Beach from Ohio in 1945, they purchased the 10-room Travelers Motel, where they worked as resident owner/managers. The motel's sign, as photographed in the early 1950s, advertised the approval of Quality Courts United, a company that set exacting standards for its member motels. (Gorry.)

Pennsylvania native Wally Skiscim developed an interest in photography at a young age. When he enlisted in the US Navy at age 17, he was able to pursue that passion while serving his country. In this 1943 shot, Photographer's Mate First Class Skiscim participates in the making of a Navy training film. (Skiscim.)

After World War II, Wally Skiscim received an honorable discharge from the US Navy, married Mary Anne Maher, and set up shop in Vero Beach as a photographer. The humble beginnings of the business are demonstrated by the old Ford pickup truck, pictured, that Skiscim purchased from the Leffler family. But Skiscim Photography became a veritable institution, serving the Vero Beach community until Wally's retirement in 1996. (Skiscim.)

57

After the tiny Vero Beach Municipal Airport began hosting Eastern Air Lines in its transport of mail and passengers, a larger terminal building was added. In this photograph, significant hurricane damage is visible. While the "Eastern Air Lines Waiting Room" sign remains intact, the "Vero Beach" and "Winter Home of the Brooklyn Dodgers" signs above it have sustained heavy damage. (IRCHS.)

After World War II, Bud Holman offered a creative use for the former naval air station: baseball. The barracks could house the players and staff, and the fields could be converted easily into baseball diamonds. Holman thought the Brooklyn Dodgers would be the perfect fit. In 1947, Holman and Mayor Merrill Barber extended an invitation to Branch Rickey, and the 104-acre facility became Dodgertown. (Holman.)

Dodgers owner Walter O'Malley (left) shakes hands with Bud Holman at the 1953 dedication of the Dodgers' spring training stadium. The plaque reads, "The Brooklyn Dodgers dedicate Holman Stadium to honor Bud L. Holman of the friendly city of Vero Beach." Just four years later, O'Malley would move the Dodgers from Brooklyn to Los Angeles, but the team would continue to train in Vero Beach for more than 50 years. (IRCHS.)

Moving from their previous spring training facility in the Dominican Republic to their new home in Vero Beach, the Brooklyn Dodgers wait in line to clear customs at the Vero Beach Municipal Airport. The proximity of the airport to Dodgertown (just a few hundred yards) was one of the amenities Vero Beach had to offer the team. (Holman.)

59

Local dignitaries board an Eastern Air Lines charter flight to the 1949 World Series pitting the Brooklyn Dodgers against the New York Yankees. Pictured, from left to right, are (first row) Dora Belle Holman, Judge Luster Merriman, Fred Briggs, and four unidentified gentlemen; (second row) drugstore owner Charles "Doc Charley" McClure; (third row) Miles Warren and Bud Holman; (fourth row) *Vero Beach Press Journal* owner John Schumann Jr., John Schumann Sr., and unidentified; (fifth row) department store owner Lawrence Maher Jr., pilot Capt. Frank Bennett, and Harry "Bump" Holman. The Dodgers had beaten the St. Louis Cardinals to win the National League pennant. The Dodgers' new friends from Vero Beach would be disappointed by their team's five-game-to-one defeat, but they would witness a historical moment: in the fifth game, when darkness fell and the game was not yet finished, the lights at Ebbets Field were turned on, leading to the first artificially-lit conclusion to a World Series game. (Holman.)

This photograph was taken on Saturday, December 17, 1949, when a new streamliner (an aerodynamic style of passenger train introduced in the 1930s) stopped in Vero Beach on its maiden journey from Cincinnati to Miami. Known as the New Royal Palm, this train was the newest member of the Florida East Coast Railway fleet that would provide daily service up and down the coast during the winter months. More than 1,000 local residents gathered to greet the New Royal Palm, including, from left to right, beginning with the lady looking over the shoulder of the boy in the striped shirt, Elena K. Mead, Thomas Trent, Marcel Boudet, Earl Thatcher, Louis Burger, Betty June Zigrang Hunt, unidentified, Trucy Kromhout, and Archie Adams. Passengers were treated to Indian River oranges, and the train was christened with a bottle of Indian River orange juice instead of champagne. (IRCHS.)

Maher's Department Store pokes good-natured fun at the Brooklyn Dodgers, who returned to Vero Beach for the 1950 spring training season having lost the 1949 World Series to the New York Yankees in five games. On the left, the sign depicts caricatures of manager Burt Shotton and president/general manager Branch Rickey. (IRCHS.)

After World War II, when commercial air travel was still a relative novelty, Maher's displayed an Eastern Air Lines advertisement featuring a mannequin clad as a stewardess. The airplane shown behind her is an Eastern Air Lines Constellation model. Under the words "You can fly too!" on the poster at the lower right, an adult bird stands on a branch, looking down at a baby bird in a nest, while an airliner soars above. (IRCHS.)

In keeping with the town's love of baseball, Vero Beach Mayor Alex MacWilliam (center) and Brooklyn Dodgers president Branch Rickey (right) honor legendary baseball manager Connie Mack at a special 1950 event in Mack's honor. The young lady at the left is Vero Beach High School drum majorette Frances Knight. (IRCHS.)

Piggly Wiggly was Vero's first chain grocery store. The company was founded in 1916 in Memphis, Tennessee, and expanded to Vero Beach in the 1920s. The year 1932 saw improvements and an expansion that doubled the store's size. In 1939, the installation of a new refrigerator was so noteworthy that it garnered an article in the *Vero Beach Press Journal*. The store is pictured here in the early 1950s. (IRCHS.)

This photograph, taken around 1952, shows members of the Vero Beach Fire Department with several older firefighting vehicles surrounding a new V-8 engine truck. At that time, the police and fire departments were immediately adjacent to one another; note the "Police" sign at the far right. The old city hall building, dating back to 1925, is partially visible on the left. (IRCHS.)

Grace Lutheran Church was founded in 1917 when its original members met at the home of Hans Clemann to select an official name for their fledgling congregation. Clemann's house was on the street that bore his name, Clemann Avenue, which is now more commonly known as Forty-third Avenue. Their first chapel was built in 1919, and the church pictured here was dedicated in 1950. (IRCHS.)

After 30 years of being served by an antiquated wooden bridge, the City of Vero Beach entered into a new era of transportation when construction began in early 1950 on a new bridge adjacent to the old one. Wood was to be replaced with steel and concrete. The $800,000 structure was a double leaf bascule bridge, known more commonly as a drawbridge. Above, a crane on a barge allows workers to lift segments into place. Below, the two counterweighted "leaves" are shown in the open position while construction continues. Once dedicated, the bridge would be known as the Merrill P. Barber Bridge, after one of Vero Beach's most distinguished citizens. (Both, IRCHS.)

The Merrill P. Barber Bridge was dedicated with great festivity on March 18, 1951. On hand to cut the ribbon is Irene Young (in wheelchair), the widow of Anthony W. Young, Vero's first mayor. Anthony served from 1919, when the town was first incorporated, until 1921. He later served in both houses of the Florida legislature, and passed away in 1948. (IRCHS.)

On the day of the dedication of the Merrill P. Barber Bridge, its namesake (standing left) is presented with a certificate of appreciation as Thomas Stewart (center), chairman of the Indian River County Commission, looks on. Having settled in Vero as a small child in 1913, when his family moved from Missouri, Barber was the president of the Indian River Citrus Bank and had a well-respected political career. (IRCHS.)

The year after the bridge dedication, Merrill P. Barber received another honor, this time for his "initiative and contribution, beyond ordinary responsibilities, to improve your Government." Having served as mayor of Vero Beach from 1947 to 1949, Barber would go on to be elected to the Florida Senate, serving two terms in Tallahassee, from 1954 to 1958 and from 1964 to 1968. (IRCHS.)

"In Flanders Fields the poppies blow, between the crosses, row on row." These are the opening words of the poem "In Flanders Fields," by Canadian lieutenant colonel John McCrae, who was moved by the growth of beautiful red poppies over Belgian battlefield graves. Ever since, the American Legion has promoted the wearing of red poppies in remembrance of the fallen. Here, Dorothy Vickers (right) and her son Jack participate in this tradition. (IRCHS.)

In 1952, a fundraising campaign allowed for the construction of an entirely new hospital at Twentieth Avenue and Twenty-sixth Street on a plot of land donated by the City of Vero Beach, pictured above. This one-story building would be the city's third hospital (though only one hospital location has ever existed at any given time). The 35-bed facility was named Indian River Memorial Hospital in honor of those who had given their lives in the service of their country. Shortly after opening its doors, it became the smallest hospital in the United States to be accredited by the Joint Committee on Accreditation of Hospitals. Below, a 1950s ambulance backs up to the emergency room. (Both, IRCHS.)

The First United Methodist Church began in 1914 as the First Methodist Church of Vero. After receiving its first resident pastor in 1921, the church added a parsonage. By the time of World War II, First Methodist had 300 to 400 members and continued to grow. The present-day church building, located at Eighteenth Avenue and Twentieth Street, was dedicated in 1951. (IRCHS.)

Having received its own resident priest for the first time in 1929, St. Helen Parish was able to establish a school and additional ministries. By the 1950s, the time had come for a major construction project, and a $250,000 funding campaign was undertaken. The beautiful new Spanish-style church was dedicated on March 6, 1955. With the largest congregation in Vero Beach, St. Helen is the spiritual home of over 10,000 residents. (IRCHS.)

This photograph dates to 1953, the year of the first Hibiscus Festival, when Vero Beach was dubbed the "Hibiscus City." The idea is credited to *Press Journal* editor Harry Schultz, who loved the beautiful and ubiquitous hibiscus flowers and wanted to establish an annual event that would both draw visitors and allow local residents to celebrate life in Vero Beach with food, music, crafts, entertainment, shopping, and charitable events. (IRCHS.)

American Legion Post 39 of Vero Beach is one of the oldest posts in Florida, having been founded in September 1919, the same month the United States Congress approved the Legion's national charter. In this 1954 photograph, Leo Schlitt (far left) and John J. Schlitt Sr. (far right) celebrate the 35th birthday of Post 39, along with two unidentified men in uniform. (Schlitt.)

The Jewel Palms Deluxe Motor Hotel and Coffee Shop, located at the corner of Ocean Drive and Camelia Lane, is shown around the mid-1950s. Each room boasted air-conditioning, a television, a refrigerator, and—as odd as it may seem—electric heat, which would have been used only on the rarest of occasions. It also featured cypress-paneled bedrooms. (IRCHS.)

The 1955 Dodgers, shown here at spring training in Vero Beach, were just months away from making history by winning the team's first World Series championship. It was the only time the Dodgers would achieve this honor while based in Brooklyn. The team included six future hall of famers, including Sandy Koufax (third row, second from left), Jackie Robinson (third row, fourth from left), and Tommy Lasorda (first row, ninth from left). (IRCHS.)

71

Even the street names within Dodgertown are notable. One example is the intersection of Sandy Koufax Lane and Jackie Robinson Avenue. Koufax, the great left-handed pitcher who spent his entire Major League Baseball career (1955 to 1966) with the Dodgers and garnered three Cy Young awards, shares a signpost with Robinson, the legendary color barrier breaker, also a career Dodger (1947 to 1956), who achieved a lifetime batting average of .311. (Dodgers.)

When the Brooklyn Dodgers came to town for spring training, photographer Wally Skiscim was there to capture it on film. The seven players touching their bats together in this photograph include center fielder Edwin "Duke" Snider (second from left) and right fielder Carl Furillo (fourth from left), both of whom were known to be quite handy with a bat. (IRCHS.)

Renowned performer Emmett Kelly, pictured in his "Weary Willie" clown persona, appears at home plate in Holman Stadium, wielding his famous broom in place of a baseball bat. Kelly was hired by the Brooklyn Dodgers organization in the mid-1950s to entertain fans at Dodgers games in both New York and Vero Beach. Kelly had a residence in Florida, as Sarasota was the winter home of the Ringling Bros. and Barnum & Bailey Circus. (IRCHS.)

Team pilot Harry "Bump" Holman smiles down from the cockpit at Dodgers owner Walter O'Malley (left) and Holman's father, Bud, who had been instrumental in bringing the Dodgers to Vero Beach for spring training. The photograph was taken in 1957, the year the Dodgers moved from Brooklyn to Los Angeles. (Holman.)

The Vero Drive-In Theatre, managed by Jack Chesnutt Sr., existed from 1950 until 1980. Featuring a concession stand, a playground, and rain-or-shine service, it attracted approximately 50 to 75 cars in attendance each weeknight and 200 to 250 on weekends. It was also known for its entertaining promotional gimmicks, such as the one pictured here, in which a group of teens advertises the 1955 movie *Chief Crazy Horse*. (Kaser.)

Nationally known cartoonist Fontaine Fox, known for his *Toonerville Trolley* comic strip, often spent his winters in Vero Beach, residing at the Del Mar Hotel. An avid golfer, Fox was one of many famous residents, both seasonal and year-round, of Vero Beach. His comic strip ran in newspapers across the United States from 1913 to 1955. (IRCHS.)

Representing Hogan and Sons growers, from left to right, Roy Hogan, Cola Streetman, Thomas Hogan, Felder Gunter, and Ray Hogan show off their tomato crop in the early 1950s. Thomas, the founder of the company, settled in Vero in the late 1910s. Roy and Ray were his sons, and Cola and Felder were his sons-in-law. (Hogan.)

This seemingly candid shot of Hogan and Sons' tomato harvest is actually a staged scene created for the cover of *International Harvester Magazine* around 1957. The sprayer in the background would have been employed prior to the harvest, not concurrent with the pickers. Felder Gunter stands in front of the truck, and Ray Hogan carries a crate at the right front, next to the lady in the hat. (Hogan.)

After Orla and Leah Shelton sold the Travelers Motel around 1953, they bought Frosty Manor, which they owned well into the 1960s. Several family members helped out at the restaurant, but it was Leah's homemade ice cream that stood out. Above, a "curb girl" dressed in the distinctive majorette uniform serves customers in a 1951 Chevrolet at the drive-in, which had its own kitchen. Below, a packed house shows the popularity of Frosty Manor among patrons of all ages. The waitress in the foreground is Ann Shelton, the wife of Orla and Leah's son Wallace "Wally" Shelton. Wally chipped in by working in the curb service kitchen. (Both, Gorry.)

Members of the Indian River Riding Club used to gather for popular matches of "palmetto polo," a sport which originated in Florida. It differs from traditional polo in that a large rubber ball is used and the mallet handles are made from palm branches. This 1950s photograph shows, from left to right, Tam Moody, William Holland, Victor Knight, Chet Coffey, Billy Lewis, Gilbert Barkosky, Kenneth Prince, and Henry Lewis. (Knight.)

D. Victor Knight cracks a whip as he rides in a parade probably commemorating Labor Day in the mid-1950s. Having followed in the footsteps of his father, John M. Knight, in the citrus and cattle businesses, Victor was an avid horseman and member of the Indian River Riding Club (note the logo on his chaps). The building in the background is the Del Mar Hotel. (Knight.)

The First Church of God was founded in 1941 by a small group of faithful led by Florence Crawford. In 1942, she rented out the Women's Club building for Sunday school services. The seed was planted for the community's first church building when a friend of Crawford's began a building fund with a $6 contribution, and in 1943, Rev. L.S. Mowery became the church's first pastor. The following year, the minister obtained a great deal on a piece of property on Fourteenth Avenue and borrowed a block-making machine with which he personally made the blocks that were used when construction was begun that spring. The resulting church (pictured) served the congregation until increasing growth led to the 1959 acquisition of a four-and-a-half-acre property at the corner of Twenty-seventh Avenue and Sixteenth Street. The second location was used for various purposes until the final move was made when a larger sanctuary was built there in 1986, replacing the Mission-style church shown here. (IRCHS.)

Three

PROGRESS IN A SMALL TOWN

The bride in this 1957 wedding photograph is Margaret Cox, daughter of Charles "Cephus" Cox, who settled in Vero Beach with his wife, Esther, in 1930 and founded the town's first funeral home. The groom is J. Charles "Charlie" Gifford, grandson of Vero Beach pioneer Henry T. Gifford. When Charlie completed his funeral service education, he became first the business partner and then the son-in-law of Cephus. (Gifford.)

In 1946, William Wodtke Sr. became the sole owner of Wodtke's Department Store, and in 1960, a second location was added in the Miracle Mile Shopping Plaza. As they grew up, all seven Wodtke children worked in the family stores at one time or another. The original location closed in 1980, while the Miracle Mile store remained in business until 1995. (IRCHS.)

In June 1954, Vero Beach's own 250-watt radio station broadcast for the first time. Because Vero Beach has often been referred to as "where the tropics begin," the station took the call name WTTB. Among other things, the station featured news, local school programs, morning devotional programs, sports news, and full coverage of Vero Beach High School football. WTTB can still be found at 1490 on the AM dial. (IRCHS.)

The Antioch Primitive Baptist Church was established in 1908 when a group from the Primitive Baptist Church at John's Island, which dated back to 1887, set up a congregation on the mainland. It is the newer church that has endured. Here, the faithful gather in July 1957. Primitive Baptists became a distinct group in the early 1800s; their worship is characterized by the absence of choirs and musical instruments. (ABC.)

Kiwanis Club members, from left to right, Rev. Melton Ware of the First Methodist Church, local businessman O.D. "Bud" Honeywell, and county judge Otis M. Cobb look dapper with their walking sticks and hats. The Kiwanis Club in Vero Beach dates back to the 1930s and has performed many services in the community. (IRCHS.)

Burnell "Bud" Emlet and his wife, Gertrude, were truly hands-on owners of Emlet's Restaurant. Bud was known to arrive at work at 4:00 a.m., and Gertrude would follow at 6:00 a.m. Among other things, she made all the pies served at the restaurant. Once the lunch crowd began arriving, Gertrude acted as hostess, and then as they left, she manned the cash register. The sign reflects Bud's love of fishing. (Smith.)

The Indian River Citrus Bank, pictured here in the mid-1950s, opened in 1935, at the corner of Fourteenth Avenue and Twentieth Street, in the building previously occupied by the Farmers Bank of Vero Beach since 1915. By 1941, it had surpassed $1 million in assets. An $80,000 expansion and remodeling was undertaken in 1951. The digital time-and-temperature display sign was added in the early 1950s. (IRCHS.)

Florida National Bank was founded in 1888, but it did not expand into Vero Beach until the 1950s. Above, from left to right, Larry Maher Jr., Thomas King, Arthur Block, William Letchworth, and Rainey Duncan gather for the 1956 ground-breaking of the Florida National Bank at Twentieth Street (later Place) and Tenth Avenue. The finished building, seen (below, which opened in 1957, boasted the first drive-through bank window in Vero Beach. Another trademark of this main branch was the metal grillwork enclosing the teller area. The teller cages were maintained even after 1980s renovations and acquisition by First Union Bank in 1990. The building, which remains largely unchanged, is now owned by Wells Fargo, and the original grillwork remains intact. (Both, IRCHS.)

The convenience of drive-through banking had already existed in Vero Beach for over a year and a half when the Indian River Citrus Bank opened this motor-banking facility in December 1958. Because it was across the street from the main building, a connecting tunnel had to be dug under the street in order to comply with Florida banking laws. Used only by employees, the tunnel was eventually filled in. (IRCHS.)

Formed in 1952, the Dolphinettes were a team of young water ballerinas and synchronized swimmers who performed under the direction of Mildred Frasier. They travelled and also performed locally, often at the Windswept resort. In 1953, they appeared in the Esther Williams film *Easy to Love*, which was filmed at Cypress Gardens. The group, which consisted of one to two dozen members, promoted Vero Beach as the "Year Round Vacationland." (IRCHS.)

November 5, 1958 was designated as Waldo Sexton Day, celebrating the indomitable pioneer resident who made an indelible mark on Vero Beach. Having arrived in Vero in 1914, Sexton planted citrus groves, ran a cattle ranch and dairy farm, and developed several buildings that are instantly recognizable to this day as his handiwork. Frequently described as "eccentric," he was an extremely avid collector of art, antiques, and miscellany from auctions, estate sales, and just about any place he could find them. Waldo Sexton Day included a performance by the Vero Beach High School Band (pictured above) and a parade featuring floats representing organizations such as the Jaycees (shown below). On that day, Sexton Plaza, located near the Ocean Grill Restaurant, was dedicated in Waldo's honor. Sexton died nine years after this event. (Both, Sexton.)

In 1923, a group of African American residents established a humble "bush harbor" church on the land of Elsie Walker. Located in the "Spillway" area of town adjacent to the main canal, the Baptist church, known initially as St. Ester, was Vero's first African American church outside Gifford. As the congregation grew, a proper church building was needed, and the Rev. Harrison Parker donated some additional land for a small wooden church. It was around this time that the name was changed to Mount Zion Missionary Baptist Church. In 1959, a much larger building project was undertaken. Above, members gather to break ground for the new church, pictured below. Mount Zion members worshipped there until 2004, when the church was damaged irreparably by Hurricanes Frances and Jean. The congregation rebuilt at the corner of Forty-third Avenue and Forty-fifth Street (Both, MZMBC.)

By 1957, the Piper Aircraft Corporation had already experienced 30 years of changes and fluctuating fortunes when it expanded its operations from two Pennsylvania plants to include a new location on the property of the Vero Beach Municipal Airport, taking advantage of facilities formerly used by the naval air station. Initially a "development center," at which new aircraft were designed and prototypes tested, the new Piper plant held an open house in January 1958, and the public was introduced to the PA-25 Pawnee, the first Piper airplane designed and built in Vero Beach. Three years later, local architect David Robison designed a 150,000-square-foot addition that included a state-of-the-art assembly turntable that was 114 feet in diameter. The production line is shown above. Below, high school students gather outside the Piper factory as they tour the facility.

The first Piper model to enter production at the Vero Beach plant was the PA-28 Cherokee. By the end of the 1960s, the Vero Beach factory was building 7,000 Cherokees per year. In 1984, the company finally shut down both of its Pennsylvania plants; operations were then limited to Lakeland, Florida, and Vero Beach, which became the corporate headquarters. Above, an aerial view of the Piper complex shows dozens of completed airplanes awaiting delivery. Below, a Piper employee works on the assembly of an aircraft. Over the years, the company has hired and laid off workers according to the demand for its various models, but Piper remains one of the largest employers in Vero Beach. (Both, IRCHS.)

In this 1959 photograph, Mayor Harry Offutt Jr., who served from 1958 to 1961, cuts the City of Vero Beach's 40th birthday cake. He is flanked by two former mayors: Alex MacWilliam (left) and Merrill Barber (right). Topped with the years 1919 and 1959, the cake is adorned with representations of various aspects of life in Vero Beach: palm trees, a church front, and the municipal services of water and power. (IRCHS.)

This 1959 postcard shows a scene from the Riomar Bay Yacht Club, which was owned by Paul and Jane Semon and their son Arthur and his wife. The club offered tennis, swimming, and a large and luxurious dining room. One of the gentleman under the umbrella (second from left) seems to be making a toast, while another prepares his approach on the diving board. (Smith.)

Jaycee Park was dedicated on March 22, 1958, by Gov. LeRoy Collins. For many months, members of the local Junior Chamber of Commerce (Jaycees) worked every weekend to clear the nine-acre site and build the park's pavilions. One such occasion is shown above. The work was often a family occasion, with the wives preparing picnic lunches for their husbands and children. (Schlitt.)

Bill F. Kaser and his son Bill H. entered the television business in 1959. They are shown here with their first company truck, a Volkswagen van sporting the TV logo and a telephone number. The year after this photograph was taken, Bill A. Kaser was born to Bill H. and his wife, Joan, providing another generation of "Bills" who would be involved in the family business. (Kaser.)

Moviegoers line up at the Florida Theatre in December 1961 to see the Disney film *Babes in Toyland*. When the 850-seat venue opened as the Vero Theatre in 1924, its debut showing was *The Hunchback of Notre Dame*. In 1937, the marquee was added and the name was changed to the Florida Theatre. The final film shown at the Florida Theatre was *Desperately Seeking Susan* in 1985. (Brackett.)

This undated photograph was taken during an event at the Florida Theatre. The movie theater seats, many of which are occupied, are visible on the left. The stage, seen at the right, was sometimes used as a venue for special events, such as performances by the Vero Beach High School band. On these occasions, it was not unusual for young people to leave their seats and dance in the aisles. (Brackett.)

By 1961, under the leadership of the Reverend Jamie W. Oppert, the First Baptist Church began a building campaign, and the cornerstone of a new sanctuary building was laid in November of that year. Below, onlookers gather to watch the construction of the 115-foot steeple on the new church in early 1962. The Georgian Colonial–style church, shown at left, was completed in time for Easter Sunday celebrations that year. The $300,000 church would serve the needs of a congregation that had grown to 1,550 members. The new sanctuary was just the beginning of a complex that would eventually grow to fill almost an entire city block. (Both, IRCHS.)

This early 1960s parade passes by Park's Ladies' Shop, which was run by two Sebastian women; the Smart Shop, a ladies' clothing store owned by Vera Zigrang Ingalls; and Loy's Menswear, which was owned by George W. Loy, who arrived in Vero in the 1920s. This was the third and last downtown location occupied by Loy's before moving to the Vero Mall in the 1970s. (IRCHS.)

Ten students of the Maryan Carlson Dance Studio perform at a recital in the mid-to-late 1950s. Carlson, a native of Rockford, Illinois, settled in Vero Beach in 1953 and opened her dance studio, which she owned until her retirement. She spent the rest of her long life in Vero Beach, passing away at the age of 98 in 2010. (IRCHS.)

This 1960s-era photograph shows South Beach during the time it included a playground. As the widest beach on the Treasure Coast, it was the perfect location for the swing set, slide, and animal spring riders seen here. Off to the left, there is also a giant turtle for the children's climbing pleasure. (IRCHS.)

Humiston Park, one of Vero Beach's popular beach recreation areas, is named for Dr. W.H. Humiston, an Ohio native who settled in Vero in 1919. Seeking to make Vero Beach the most beautiful small city in Florida, he established the Beautification Society in 1929. Humiston died in 1943, and the municipal beach park was dedicated to him in 1953. (IRCHS.)

Maher's Department Store was founded by William J. Maher, who was born in 1871 in Illinois and arrived in Vero in 1915 with his wife, Catherine. His store, opened in 1916, was the first modern department store in town. It is amusing to note that in this photograph, the sign reads "Maher's Tropical Fashions," while the mannequin in the window is clad in denim overalls. (IRCHS.)

Howard Lee Clements (left), known as "P.O." for reasons that are unclear even to those who knew him well, receives a mail-ordered outhouse (also for reasons that are unclear) from F.A. York of Norman Park, Georgia. He is accompanied by longtime friend Harry "Bump" Holman. It was Holman's father Bud who first invited Clements to move to Vero Beach around 1930. (IRCHS.)

P.O. Clements's interests were many and varied. He worked for Eastern Air Lines as assistant station manager at the Vero Beach Municipal Airport, where Bud Holman was the manager. The two friends and coworkers split 10 acres of land on Sixteenth Street, just west of Forty-third Avenue. On his property, Clements built a private saloon called the Fool's Den, known by friends simply as "the Den," seen at left. Clements took up new hobbies frequently and was a collector of all sorts of items, as seen in the photograph below of a musical get-together inside the Den. Note the toilet seats used as picture frames. (Both, IRCHS.)

This photograph appears in a Vero Beach tourism brochure from around the early 1960s. It features Taylor "Tate" Simpson (center) and an unidentified child and woman. A St. Louis native and Navy aviator in the Pacific theater of World War II, Simpson moved to Vero Beach in 1955 and entered the real estate business with his brother-in-law David Langfitt. Simpson was a city council member and served as mayor from 1968 to 1971. (IRCHS.)

This image is a 1960 season ticket for Vero Beach High School football games. The ticket belonged to Orval Shelton, the son of Orla and Leah Shelton, who owned the Frosty Manor Restaurant. Vero Beach residents have been proud of their Fighting Indians since the team was formed in the 1920s. Several Vero Beach High School alumni have gone on to play in the National Football League. (Gorry.)

VERO BEACH HIGH SCHOOL

1960

Football Season Ticket

ALL GAMES 8:15 P.M.

Issued To *Orval Shelton*

Sec. C Row 6 Seat 3 Admission Price, $6.75

Sept. 23 Palmetto | Oct. 7 Titusville | Oct. 21 Stuart | Oct. 28 Edgewater | Nov. 24 Ft. Pierce

In 1960, Walter and Elvira Buckingham donated 23 acres of land to the Florida Baptist State Convention for the purpose of establishing a residence for the increasing number of senior citizens in Vero Beach. Thus was born the Florida Baptist Retirement Center, which has grown to include independent living villas, as well as facilities for group living, assisted living, and skilled nursing. (IRCHS.)

After 39 years in Vero Beach's original city hall (seen on page 19), all of the town's municipal departments were more than ready to relocate to a new facility. The new city hall was built on the southeast corner of Twentieth Place and Eleventh Avenue, just a few blocks from the 1920s city hall building. City employees were jubilant as they made the move in early 1963. (IRCHS.)

Within 20 years of the construction of the original Indian River County Courthouse, it became apparent that additional space would be needed. In 1956, the south wing was added, significantly increasing the available office space. Then, in 1961, E.M. Netto Construction built the north wing, which further increased office space, and added a second courtroom on the second floor. (IRCHS.)

The Woman's Club building housed the Indian River County Library for over 40 years, by which time some 16,000 volumes had been accumulated. The second library, designed to evoke the image of three books standing between two bookends, was built on Twentieth Street in 1962. The bookmobile was added in 1963, vastly increasing the library's circulation numbers. (Library.)

Architect David Vincent Robison is seen here with his daughter Jan at the Hibiscus Air Park in the early 1960s. Robison was a member of the Suncoast Soaring Association, a local group of glider aficionados. Robison designed many of the flight-related buildings in Vero Beach, including those of Piper Aircraft and FlightSafety Academy. The glider shown here is Robison's Schweizer SGS 1-26. (Robison.)

Founding member of the Suncoast Soaring Association John Dezzutti works on his Schweizer SGU 2-22 ship, a training glider he built from a kit in 1958. At the Hibiscus Air Park, which was located south of Vero Beach High School, a dedicated group of gliding enthusiasts sometimes used Dezzutti's station wagon to tow their gliders into takeoff position. (Robison.)

The Turf Club Restaurant, now the Szechuan Palace, on Forty-third Avenue, is a part of the legacy of Waldo Sexton, a collector of all sorts of artifacts, from bones to bells, which he often included in his various building projects. As seen above, Sexton saw beauty in items that others may consider to be junk, but he brought these items together in a way that represented his unique style. (Sexton.)

In this photograph taken in the early 1960s, the members of the Araba Shriners, based in Fort Myers, riding on minibikes, participate in the Vero Beach High School homecoming parade. At the right is a member of the clown division of the Mahi Shriners of Miami. The parade is heading north on an unpaved Fourteenth Avenue, just north of Sixteenth Street. (DuBose.)

Local members of the junior chamber of commerce present a dignitary with a case of Indian River citrus while attending a national Jaycees convention around the mid-1950s. Standing from left to right are Hugh Corrigan, Earl Groth, unidentified, Claude "Buck" Hart, Orval Shelton, Frank Schlitt, Edgar "Ed" Schlitt, and Frank Dancy. Crouching in front is Robert Spillman. As Florida Jaycees, they wear their trademark blue and orange uniforms. (Schlitt.)

Many prominent businessmen in the history of Vero Beach have been members of the junior chamber of commerce (Jaycees), including Orval Lee Shelton, a general contractor who formed the Shelton Construction Company in 1948. At the end of the membership year following each Jaycee's 41st birthday, he would become an "exhausted rooster," a humorously affectionate term applied to members who had aged out of the organization. (Gorry.)

102

Pocahontas Park has existed at the corner of Twenty-first Street and Fourteenth Avenue since Vero's earliest days, but it has undergone many changes. At one time, the five-acre park featured a small zoo that included a bear. In the early 1930s, the Garden Club of Indian River County beautified the park with a lily pond and rock garden. The Spanish-style Community Building, shown above, was added in 1935. In addition to tennis and shuffleboard courts, Pocahontas Park has long been known for its playground, which has also changed over the years. The playground is shown below in 1964; visible in the background is the F2H-2P Banshee reconnaissance airplane, an authentic Korean War–era military aircraft that was enjoyed by Vero Beach's children from 1959 until its removal in 1988 to the National Naval Aviation Museum in Pensacola. (Both, IRCHS.)

The Vero Beach High School cheerleaders are shown riding past Hart's Furniture Store in a convertible from Gale Oldsmobile, probably during a homecoming parade during the mid-1960s. In 1970, Gale Oldsmobile was bought by Olaf Vatland, and the business was continued by his son Robert after Olaf passed away in 1974. Hart's was owned by Clyde "Buck" Hart and his mother Thelma. (Brackett.)

Several unidentified ladies attend a booth selling handcrafted items at the 1967 St. Helen Catholic Church Harvest Festival. The annual event has been a major attraction for the community and a major fundraiser for the parish since 1964. In the early days, the festival was held on the church grounds, but as it grew, it moved to the spacious grounds of Dodgertown. (Schlitt.)

This photograph shows a FlightSafety hangar at the Vero Beach Municipal Airport, probably in the late 1960s. FlightSafety International is a company that owns some 40 pilot-training facilities all over the world. The FlightSafety Academy at Vero Beach, established in 1966, has become a prestigious flight training facility that attracts students from around the globe. (IRCHS.)

This 1966 photograph was taken at a chamber of commerce dinner honoring the organization's past officeholders. Pictured, from left to right, are (seated) John Wheeler, Alma Lee Loy, Earle Thatcher, Sam Moon, Freeman Knight Sr., Warren Zeuch Sr., and James Vocelle Sr.; (standing) Marshall Mitchell, Ralph Sedgewick, Justin Schumann, Bob Cavendar, Edgar "Ed" Schlitt, J.H. Southerland, Joe Henry Earman, Harold Hicks, Roy Schick, and Angelo Sanchez. (IRCHS.)

Vero Beach's third consecutive hospital facility continued to grow in an effort to keep pace with the influx of new residents. In 1956, a 25-bed addition brought the facility to a patient capacity of 60, and another addition in 1962 raised the number of beds to 100. By 1967, major expansions, including the addition of two stories, brought the bed total to 164. (IRCHS.)

The Little Hut was a 1960s restaurant and cocktail lounge with a Polynesian theme. For example, it featured dining and dancing in the Bambu Room. It also had a gift shop offering "a rare selection of gifts and oddities from throughout the world." The building, located on Royal Palm Boulevard (now Royal Palm Pointe), has changed hands several times, but the stone structure in front remains intact. (Smith.)

Four

TOWARDS THE CLOSE OF A CENTURY

This photograph shows DuBose Jewelry, Vero's first jewelry store, in the 1960s. At its peak, the DuBose business included seven stores along the Treasure Coast. Now housed in a single location on Old Dixie Highway, the business has remained in the DuBose family, which is now in its fifth generation of jewelers. (DuBose.)

The Osceola Building is shown here in both its early days (above) and its final moments (below). Consisting originally of apartments on the second floor and offices, a beauty shop, and a drugstore on the first floor, it was also the first location of Loy's Menswear. Later, it housed WGYL, a local easy-listening station owned by the Hubbard family. The building, with its beautiful arches, was located at the corner of State Road 60 and Fifteenth Avenue. It was demolished in the late 1970s and replaced for a time with an empty lot. Later, the new Indian River County Courthouse was built on the site. (Both, IRCHS.)

The Vero Marine Center opened in 1957 as the first marine business in Indian River County and the first building on what is now Royal Palm Pointe. The company, shown here in the 1970s, has remained in the same location for all of its 56 years, selling and servicing boats and motors and maintaining 50 boat slips. It is owned by Bruce MacIntyre. (MacIntyre.)

The Garden Club of Indian River County was founded in 1928 by a group of female gardening enthusiasts. One of its missions over the years has been to beautify the roadways, parks, and grounds of many public buildings in Vero Beach with its horticultural and landscaping expertise. Here, seven club members work on sprucing up the grounds of the Visiting Nurse Association of Indian River County. (IRCHS.)

As demonstrated by the above photograph, one of the features that distinguishes Vero Beach from many coastal towns is the absence of high-rise buildings. The laws of Indian River County have always limited building heights to three stories; buildings within the city limits of Vero Beach, such as those pictured above, were allowed a maximum of five. In 1973, city officials discovered that the wording of their height-restricting ordinances was not as unassailable as they had thought. That year, a developer challenged the height limits and obtained permission to construct the 13-story Village Spires condominiums pictured below. City officials wasted no time in closing all loopholes that could allow a similar incident in the future. Eventually, the city adopted the county's three-story maximum. To this day, the Village Spires remain the only buildings in Vero Beach that exceed five floors. (Both, IRCHS.)

On October 20, 1977, ground was broken for the 17th Street Bridge—an event that was a long time coming. It was recognized by the early 1970s that public safety demanded a second bridge over the Indian River. The population of the barrier island was growing, and the only connection to the mainland was a single bridge. This situation could prove hazardous in the event of a hurricane evacuation. Moreover, the Barber Bridge was a drawbridge, which could wreak havoc with the work of ambulances and other emergency vehicles. The intention to build a second bridge was formed in 1971, but there was disagreement as to the location. Finally, from left to right, county commissioners Don Deeson and Willard Siebert, county commission vice chairman Alma Lee Loy, county administrator Jack Jennings, and county commission chairman William Wodtke Jr. pose at the ground-breaking ceremony for the 17th Street Bridge, which would be dedicated in 1979. In 2011, Florida House of Representatives Bill 7213 renamed it the Alma Lee Loy Bridge. (Loy.)

Sue Brock (left) and Judy Thomas fill mesh bags with grapefruits as part of a citrus promotion around 1981. The River Queen brand name was owned by the Haffield Fruit Company. Vero Beach has always taken pride in its role in the citrus industry, and grapefruit is the primary crop associated with the Indian River Citrus brand name. (IRCHS.)

In September 1975, Thomas and Linda Leonard opened the Vero Beach Book Center in the Miracle Mile Plaza. They are pictured here with their sons Todd, age two, and Chad, age one. Just a toddler in his mother's arms at the grand opening, Chad is now co-owner and manager of the family business, which is the only independent book store in Vero Beach. (Leonard.)

The view in this aerial photograph faces north, with the Kmart store, built in the mid-1970s, in the foreground. Just to the north is the Cobb Theater, the first multiplex in Vero Beach. The structures just to the northwest are part of the Russell Concrete property, and the shopping center at center left is Luria's Plaza. Just north of the water tower is the old Vero Mall. Hailed as innovative when it opened in February 1978, as enclosed malls were still a relatively new development, the 170,000 structure was tiny by today's standards. The mall was anchored by department stores J.C. Penney and J. Byrons, with 30 smaller shops in between. One of the distinctive qualities of the Vero Mall was that 30 to 40 percent of the business tenants were locally owned, with the remainder being regional or national chains. As the town expanded west, many shopping plazas cropped up, and then in 1996, the large Indian River Mall was built. By the end of 1997, the Vero Mall was in financial trouble, and it closed in 1998. (IRCHS.)

By the late 1960s, it had become apparent that a major hospital upgrade was imminent in Vero Beach. Plans began in 1971 and culminated in the construction of the new Indian River Memorial Hospital, which opened in 1978. The impressive facility was built on 80 acres of land and began with 216 beds, which later increased to 335, with the capacity for even more. The hospital features all private rooms. (IRCHS.)

Vero Beach High School has grown with the town. Like many other places, Vero began its educational system with a one-room schoolhouse. It was the mid-1920s before Vero Beach High School obtained both its own building and accreditation. The current high school, shown here in the 1980s, was constructed in 1964 and has continued to grow. Until 1994, it was the only public high school in Indian River County. (IRCHS.)

On October 10, 1982, Fr. John B. O'Hare and Msgr. Irvine J. Nugent, the pastor of St. Helen Catholic Church, the first in Vero Beach, take shovels in hand to break ground for the new church building of Holy Cross Catholic Church, the first Catholic parish on the barrier island in Vero Beach. Father O'Hare would remain the pastor of Holy Cross until his retirement in 1997. (IRCHS.)

Prior to 1979, Jewish residents of Vero Beach had to travel to Fort Pierce to participate in synagogue services. That year, a committee formed to establish a local synagogue. At first, St. Helen Catholic Church provided a meeting space. Obtaining a full-time rabbi in 1980, Temple Beth Shalom settled into its permanent location on Forty-third Avenue in 1984. Above, members work on beautifying their new peaceful wooded property. (TBS.)

In 1984, Martin and Mary Sue Walker moved from Michigan to Vero Beach and brought their restaurant business, Cravings, with them. Having begun as a small bakery that also served coffee and ice cream, Cravings has grown into a very busy breakfast and lunch spot (above) in addition to being a gourmet bakery. Its location at the corner of Ocean Drive and Bougainvillea Lane (below) has not always been perfectly smooth and scenic. Shortly after the Walkers set up shop, heavy equipment arrived to widen Ocean Drive and convert Bougainvillea Lane and other side roads into one-way streets. (Both, Walker.)

After the last train departed the Vero Beach railroad station on July 31, 1968, the building fell into disuse and disrepair. In 1984, recognizing that the depot is one of the area's oldest extant buildings, the Indian River County Historical Society purchased it from the Florida East Coast Railroad for $1. It was then moved one half mile from its original location on Commerce Avenue between Eighteenth and Nineteenth Streets to its current home on Fourteenth Avenue, where it was renovated by the Indian River County Historical Society. Since that time, it has housed the exhibit center of the IRCHS. In 1987, the depot was added to the National Register of Historic Places. (Both, IRCHS.)

Vero Beach Elementary School is as old as the town itself and has occupied four different structures over nearly 100 years. One day in 1985, students at the third incarnation of Vero Beach Elementary had the opportunity to show off their classrooms and artwork (an example of which is shown below), as well as their playground (above), when photographer Wally Skiscim came to the campus for school picture day. The school's fourth home was built on the same site, which is located at the corner of Twentieth Avenue and Twelfth Street, immediately adjacent to Vero Beach High School. Since the high school's teams are known as the Fighting Indians, Vero Beach Elementary is known as the "Home of the Little Indians." (Both, IRCHS.)

This photograph of the Ocean Grill Restaurant was taken in the aftermath of the 1984 Thanksgiving Day nor'easter that caused devastating beach erosion and severe damage to the section of the building that overhangs the ocean. As the storm battered the restaurant, the entire crew of the Service Refrigeration Company (about 10 men) rushed to rescue ice machines and other equipment as the floor collapsed around them. (IRCHS.)

This late-1980s photograph is an aerial view that looks northward from Seventeenth Street along Indian River Boulevard. The Indian River Lagoon is at the upper right, and the third power plant (built in 1961) is partially visible on the right. The Citrus Financial Building is under construction in the foreground. (Schlitt.)

This eastward-facing view (the Atlantic Ocean is visible in the background) shows the original Merrill P. Barber Bridge and, in the foreground, the area now known as Royal Palm Pointe. When the new Barber Bridge was built slightly to the north, the old bridge was dismantled and removed, and the land leading up to it became home to a pier, beautiful mosaics, and a fountain for children's frolicking pleasure. (Smith.)

In the mid-1990s, a major road project was undertaken in Vero Beach. The new "twin pairs" replaced the four-lane State Road 60 passing through downtown with two larger roadways one block apart: three eastbound lanes and four westbound. Because Interstate 95 was not yet completed, the twin pairs would aid in the necessary traffic flow from I-95 to US Highway 1, as well as aid westbound hurricane evacuations. (IRCHS.)

Having come into existence shortly after World War II, Dodgertown became quite a large sports complex. In this westward-facing view, Holman Stadium is visible slightly left of center, to the right of the golf course lake. In addition to several practice fields, there are tennis courts and a swimming pool. The players' updated lodgings are visible just beyond the two large baseball fields in the foreground. (Dodgers.)

Holman Stadium was not only the springtime home of the Brooklyn and Los Angeles Dodgers, it was also the home field of the team's affiliated minor-league (Class A Advanced) team, the Vero Beach Dodgers, which played in the Florida State League. Local residents enjoyed cheering on the "little Dodgers" from 1980 until 2006. After that, the team's major-league affiliation switched to the Tampa Bay Devil Rays. (Dodgers.)

On May 7, 1993, just north of the Merrill P. Barber Bridge, ground was broken for a modern bridge that would replace the 40-year-old drawbridge. In the photograph at left, the first shovelsful of dirt are removed by Senator Barber's daughters, Helen Barber Stabile (left) and Carolyn Barber Vreeland. The new bridge, which also bears Barber's name, was dedicated on February 18, 1995. With a height of 65 feet, it has no need to stop traffic periodically, as its predecessor did. The 3,834-foot span is supported by a series of concrete arches, which, as seen below, are quite striking in their design. (Left, IRCHS; below, author.)

BRECONSHIRE

ON 30 APRIL 1894, THE BRITISH STEAMSHIP BRECONSHIRE (FORMERLY THE NUMIDA), BOUND FROM NEW YORK TO TAMPA, STRANDED ON THE OFFSHORE LIMESTONE REEF LEAVING ITS BOILER VISIBLE ABOVE THE WAVES. THE 24-MAN CREW WAS SHELTERED BY THE U.S. LIFE SAVING SERVICE AT THEIR REFUGE STATION LOCATED ON THE DUNES EAST OF BETHEL CREEK AND ONE MILE NORTH OF THIS SITE.

INDIAN RIVER COUNTY HISTORICAL SOCIETY
1994

In 1994, the Indian River County Historical Society commemorated the 100th anniversary of the shipwreck *Breconshire*, a British steamship that ran aground while passing along the coast of what would later be known as Humiston Park in Vero Beach. For over a century, the boiler of the *Breconshire*, the only part of the ship left protruding above the water, was a fixture just offshore. (Eventually, it collapsed below the surface.) Below, a boy and a woman read the plaque placed by the Indian River County Historical Society, while the boiler is visible in the center of the photograph, just beyond the breakers. Above is a close-up of the plaque. (Both, IRCHS.)

Despite several additions, the old Indian River County Courthouse was eventually outgrown. Its successor would be built on a grand scale. The 120,000-square-foot new courthouse would stand three stories tall, the maximum allowed within Vero Beach's city limits, and would cost $21 million. It is shown (above) while under construction in 1994. The dedication festivities (below) took place on November 11, 1994, and began with a Veterans Day parade; participants were undaunted by the fact that the courthouse was not yet quite complete. After a few setbacks, including complications with the elevators, the courthouse offices made the two-block journey to their new home. (Above, Library; below, IRCHS.)

ROSE GARDEN DINING ROOM ON U.S. HIGHWAY #1 AT NORTH EDGE OF VERO BEACH, FLORIDA

Shown above around the 1940s, the Rose Garden Dining Room, also referred to as the Rose Garden Tea Room, was constructed of cypress wood and stood on the east side of US Highway 1 between Thirtieth and Thirty-first Streets. The restaurant prided itself in its pleasant dining area and home-cooked Southern fare, such as fried chicken, seafood, steaks, and pork chops. A later generation came to know the same building as Marvin Gardens, a casual bar and restaurant. After Marvin Gardens went out of business, the building was divided into two sections, one of which is shown below, and relocated to the Banack family grove. The first section was moved on February 26, 2004, and the second on March 1. (Above, Smith; below, IRCHS.)

As it has been home to one of the largest congregations in Vero Beach, the Community Church's growth led to a major building campaign in 1990 and 1991. The result was one of the most distinctive houses of worship in the area. The most impressive feature of the church is its 90-foot concrete cross, visible for blocks around. (IRCHS.)

In 1991, Vero Beach residents received a new library. In what seemed like an ironic twist, the new Indian River County Main Library was built at 1600 Twenty-first Street, just next door to the old Woman's Club Building that had served as Vero's original library back in the 1920s. The new two-story library includes a children's room, meeting rooms, and a genealogy department complete with Florida history archive. (Library.)

When Atlanta hosted the 1996 Olympics, it took 84 days for the torch to be carried relay-style from Los Angeles to Atlanta. On the 71st of those 84 days, the Olympic torch arrived in Vero Beach, having traveled down the west coast of Florida and then up US Highway 1 from Miami. A series of prominent citizens took turns carrying the torch, including Alma Lee Loy, who is shown above during her half-mile turn bearing the torch. A native of Vero Beach, Loy is venerated for her many forms of service to the community, including her role as the first woman to serve on the Indian River County Commission, as well as her work with the local chamber of commerce, of which she served as president. Loy and her business partners, Lucy and Herschel Auxier, owned a children's clothing store, Alma Lee's, which was located in the Maher Building downtown, for 40 years. (Loy.)

DISCOVER THOUSANDS OF LOCAL HISTORY BOOKS FEATURING MILLIONS OF VINTAGE IMAGES

Arcadia Publishing, the leading local history publisher in the United States, is committed to making history accessible and meaningful through publishing books that celebrate and preserve the heritage of America's people and places.

Find more books like this at
www.arcadiapublishing.com

Search for your hometown history, your old stomping grounds, and even your favorite sports team.

Consistent with our mission to preserve history on a local level, this book was printed in South Carolina on American-made paper and manufactured entirely in the United States. Products carrying the accredited Forest Stewardship Council (FSC) label are printed on 100 percent FSC-certified paper.

MADE IN THE USA